STEP-BY-STEP
Digital Photography

A GUIDE FOR BEGIN[NERS]

Seco[nd]

Jack and Sue Drafahl

AMHERST MEDIA, INC. ■ BUFFALO, NY

Special thanks to all our friends and family
who graciously didn't run away when they saw us coming with our cameras.
We couldn't have done this book without you.

Copyright © 2005 by Jack and Sue Drafahl
All rights reserved.
All photography by the authors unless otherwise noted.

Published by:
Amherst Media, Inc., P.O. Box 586, Buffalo, N.Y. 14226, Fax: 716-874-4508
www.AmherstMedia.com

Publisher: Craig Alesse
Senior Editor/Production Manager: Michelle Perkins
Assistant Editor: Barbara A. Lynch-Johnt

ISBN: 1-58428-141-3
Library of Congress Card Catalog Number: 2004101343

Printed in Korea.
10 9 8 7 6 5 4 3 2 1

Jack and Sue Drafahl are a husband and wife team of professional photojournalists, lecturers, and multimedia producers. For more than thirty years, their articles have appeared in *Petersen's PHOTOgraphic, Rangefinder, Sport Diver, Focus on Imaging, Outdoor Photographer, National Geographic World, National Wildlife Federation,* and *Skin Diver Magazine.*

They have been actively involved in the digital transition since the early '80s and are software and hardware beta testers for companies like Adobe, Applied Science Fiction, Corel, and Ulead Systems.

Jack and Sue started their professional photographic careers at Brooks Institute of Photography, Santa Barbara, California, and Jack later started the audio visual department. Both are active scuba divers, receiving their diving certification in the early '70s. Jack and Sue were awarded Divers of the Year from Beneath the Sea, and Sue is an inaugural member of the Women Divers Hall of Fame.

Their audio visual presentations have been shown at film festivals from coast to coast on topics that span the range of underwater and nature photography. They also produce multimedia presentations for award ceremonies around the world.

Jack and Sue make their home on the Oregon coast and enjoy teaching seminars worldwide on all aspects of photography, both topside and underwater. In addition to their various monthly articles, Jack and Sue are the authors of *Digital Imaging for the Underwater Photographer, Photo Salvage with Adobe Photoshop, Plug-Ins for Adobe Photoshop,* and *Advanced Digital Camera Techniques,* from Amherst Media.

For more on the authors, please visit www.jackandsuedrafahl.com.

The introduction of the digital camera has had a profound effect on photography. This new technology makes it possible to view your picture moments after it is taken; you no longer need to worry whether you've got the picture or not. With digital photography, you can take the picture over, delete those pictures

This book will simplify the learning process for anyone new to digital photography.

you don't want, and pick only a select few images for printing. The images don't get scratched, their color doesn't fade, they are easily previewed, and they can last up to 100 years on a Photo CD.

With digital photography, the traditional photo basics of focus, exposure, and framing still apply. It's the problem of electronic technology that scares many people away from the digital camera. Many so-called instruction manuals are so complex that they frighten new digital photographers away. Some manuals contain as many as 200 pages of technical diagrams and illustrations; this is way too much technical jargon to wade through, when all you want to know is how to take a picture.

This book will simplify the learning process for anyone new to digital photography. In it, we will approach digital photography with an easy-to-use, fully illustrated, step-by-step format. This doesn't mean you should throw away your camera's instruction manual—in fact, we recommend that you reserve it for use as a technical reference. Take some time to become adept with using your digital camera, and refer to your owner's manual whenever you need additional information regarding one of your camera's menus or controls.

The most significant problem we encountered when preparing this book was that new camera versions are being introduced monthly. While we included the latest, greatest cameras available to illustrate this book, we knew that newer models would be available by the time this book was in print. That is the way of the digital world.

Fortunately, the basic concepts needed to operate a digital camera are similar from one camera to the next. The only difference from model to model is the

location of specific controls and their aliases. For this reason, we have taken a cross section of digital cameras and consolidated their controls for basic digital camera operation. If you don't see your specific camera model in this book, don't worry, as basic concepts are the same from one camera to the next.

We offer this book as a tool for getting started in this exciting digital process. Enjoy.

TABLE OF CONTENTS

1

Whether a digital camera is your first camera or simply a new camera, you may find digital technology difficult to understand. We have minimized the technical jargon to make taking digital pictures fun.

2

Digital cameras come in two different types: point & shoot and single lens reflex (SLR). The point & shoot is the simplest and most popular model of the two. Since camera manufacturers no longer have to conform camera shapes to accommodate 35mm film cassettes, they can design compact models. Most point & shoot cameras have a flash on the front, are compact enough to fit in your pocket, and are very easy to use.

3

The digital SLR uses the lenses and accessories of its film counterpart. The camera bodies have been modified to use a CCD (charge-coupled device) or CMOS (complementary metal oxide semiconductor) chip instead of film for recording the images. They feature sophisticated camera functions to provide the ultimate in photo control.

4

A few digital SLR cameras have a lens that is permanently attached. These zoom lenses have an extreme optical zoom range designed to cover most photo situations. The cameras feature many of the same SLR functions like flash sync, high shutter speed, focus controls, exposure bracketing, and minimal shutter delay.

5

On the front of a point & shoot camera you will find the lens, flash, and openings for the light metering and auto-focus systems.

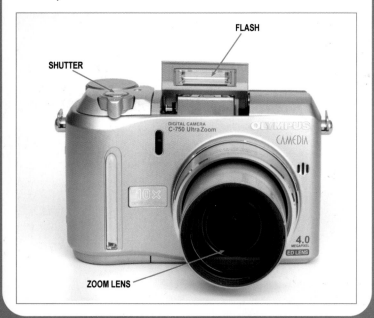

6

The top of the point & shoot camera features the shutter release button, exposure mode dial, and flash hot shoe. You may also find a few additional controls, but they vary from camera to camera.

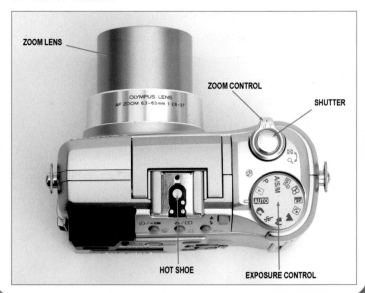

7

The back of the point & shoot camera is different from the film version. You have an LCD viewer that allows you to see the image that is being recorded by the lens. The back also features an optical viewfinder for bright situations and a toggle that allows you to navigate through the menu selections. Many cameras will have an auto exposure lock, close-up mode, and Flash mode.

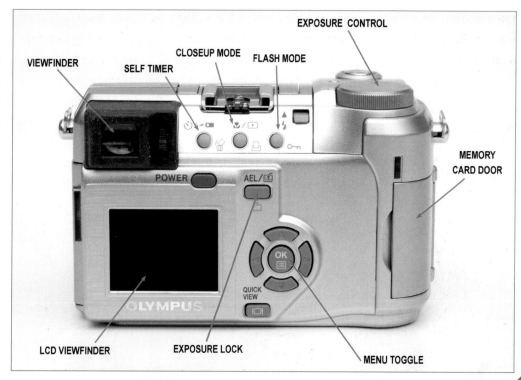

EXPOSURE CONTROL

VIEWFINDER

SELF TIMER

CLOSEUP MODE

FLASH MODE

MEMORY CARD DOOR

POWER

AEL/

QUICK VIEW

OLYMPUS

LCD VIEWFINDER

EXPOSURE LOCK

MENU TOGGLE

8

Generally, the side of the point & shoot camera is where you will find the memory card slot. There is usually a door that protects the card from dust and damage. This is also where you may find the computer USB (universal serial bus) communication port, video jack, and occasionally a battery compartment.

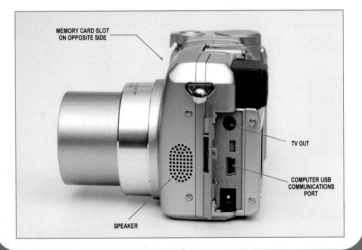

9

The bottom of the point & shoot digital camera is very simple and usually features a tripod socket and the battery compartment.

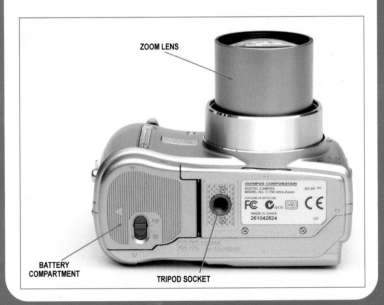

10

The front of the digital SLR looks just like its film counterpart. The best features of the SLR are its TTL (through the lens) viewing and ability to change lenses. You will find the shutter release on the hand grip, a focus control switch, lens release button, exposure compensation control, and depth of field preview.

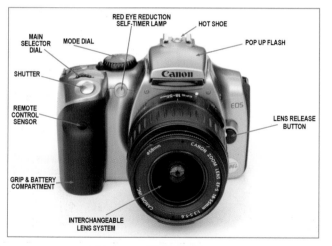

11

The top of the digital SLR features an optical viewfinder, a hot shoe (for an auxiliary flash), shutter control, exposure mode and, in certain models, an internal flash.

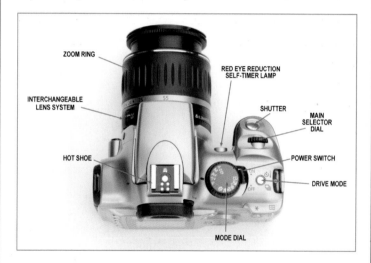

12

The back of the digital SLR looks quite different from the film version due to the presence of the LCD viewer and optical viewfinder. In addition, you will find the menu toggle, flash control, exposure bracket control, and the handy exposure and focus lock. On some models, the memory card slot is located on the back of the camera, while others feature it on the side.

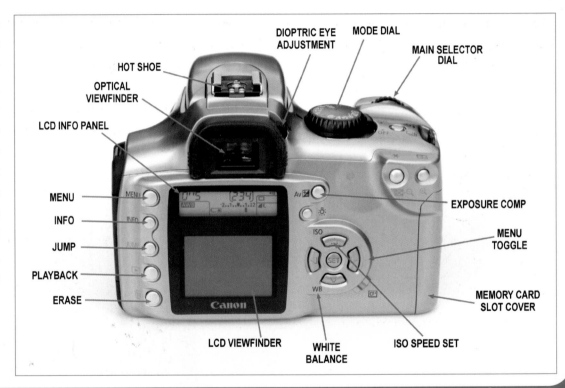

DIOPTRIC EYE ADJUSTMENT

MODE DIAL

MAIN SELECTOR DIAL

HOT SHOE

OPTICAL VIEWFINDER

LCD INFO PANEL

MENU

INFO

JUMP

PLAYBACK

ERASE

EXPOSURE COMP

MENU TOGGLE

MEMORY CARD SLOT COVER

LCD VIEWFINDER

WHITE BALANCE

ISO SPEED SET

13

The side of the digital SLR features an ergonomic hand grip, shutter release, pop-up flash and many have a memory card slot.

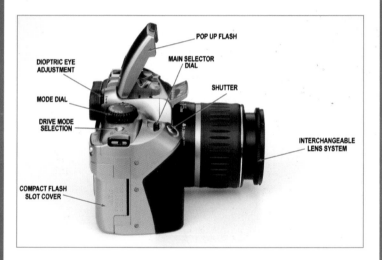

POP UP FLASH

DIOPTRIC EYE ADJUSTMENT

MAIN SELECTOR DIAL

MODE DIAL

SHUTTER

DRIVE MODE SELECTION

INTERCHANGEABLE LENS SYSTEM

COMPACT FLASH SLOT COVER

14

The shutter button is usually on the right side of the camera, located within close reach of your index finger. When you gently press the shutter button, the camera fires and takes the picture. It is best to push the shutter button down halfway when composing your photo, as this allows the autofocus function to be ready when you finally fully press the button.

15

The symbols used to represent the various exposure controls vary from camera to camera, but the majority use P for program, A for aperture, S for shutter, and M for manual. The more advanced models also feature sports (runner icon), portrait (head profile icon), landscape (mountain icon), and close-up (flower icon) modes.

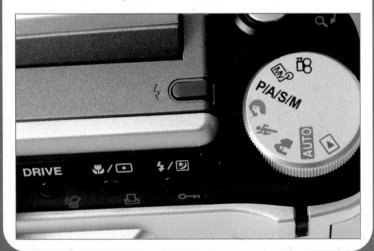

16

The zoom control is usually located in one of two places - either next to the shutter control on the front of the camera, or on the top back edge of the camera. If your camera has two zoom buttons, pressing the left will usually move the lens to wide angle and the right will extend the lens to telephoto. If you have a single zoom button, move the button to the left for wide angle and right for telephoto.

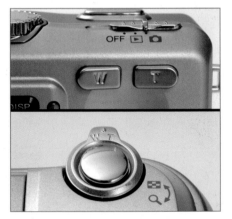

17

The menu toggle is necessary to navigate your way through the various menu functions. You must scroll up or down and left or right to activate or deactivate certain functions. You will also find a select or OK button that must be pressed to confirm your selection.

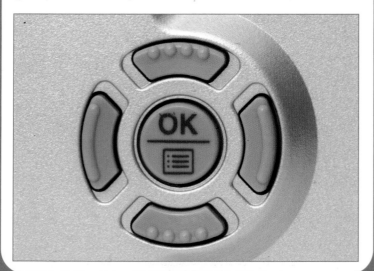

18

The two most common locations for the memory card slot are on the back of the camera or on the side. The card can only be inserted one way, so don't force the card into the camera. Check the markings on your card to ensure proper insertion.

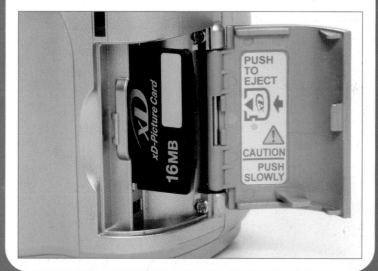

19

Some digital cameras have the ability to record your images directly to a mini CD contained within the camera. This CD can then be removed and placed into your computer to download the files.

20

The location of the close-up button varies from camera to camera, but is usually represented by a flower icon. When you select the close-up button, the lens is able to focus closer than normal, thus allowing you to capture smaller subjects. Be sure to turn this function off when you return to normal picture taking; otherwise your photos will be out of focus.

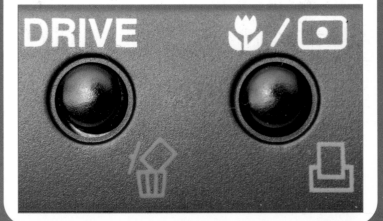

21

Most digital cameras now include an internal flash unit. The advantage to the internal flash is that it functions in conjunction with the inner workings of the camera to provide the best exposure. The disadvantage is that it provides a harsh light source that may cause red-eye.

22

Almost all digital cameras have an exposure compensation button that is either located on the top or back of the camera. Most digital cameras use a single button and a rotating dial to increase and decrease exposure. A few use a left and right arrow to accomplish the same task. The more advanced cameras may also have an exposure compensation for control of the internal and external flash units.

23

The power switch is one of the hardest buttons to locate on digital cameras. You really have to look hard to find it. Sometimes it is a button, while occasionally it may be a sliding switch. On other models, you have to slide the lens cover to the side in order to bring the camera to life.

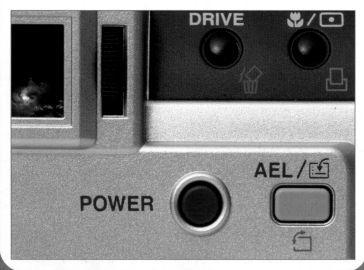

24

The biggest advantage to digital is that you can see your image immediately. The LCD viewer on the back of the camera allows you to view images as they are recorded or review photos you have previously taken. The LCD viewer also makes it easy to compose your photos, even when shooting close-ups.

When the sun is very bright, it is difficult to see your image in the LCD viewer on the back of the camera, so the optical eyepiece maybe a better choice. In addition, traditional film users may find they are more comfortable using the optical viewfinder. The LCD display on the top of the camera is reserved for viewing camera settings and doesn't display an image.

25

The swing out LCD monitor allows you to take pictures from extreme angles so you can hold the camera above the crowd, or at ground level and achieve some incredible images. This is a handy feature to consider when buying a new digital camera.

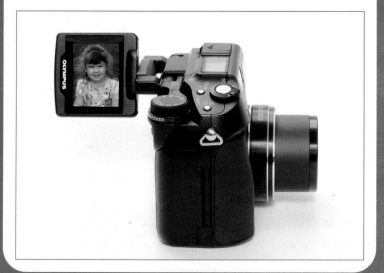

26

Many digital cameras feature a sound-recording function. This can be used to take notes as you take photos and will help you to remember pertinent information. This function can also be used to create a soundtrack, since many of the new cameras allow you to take low- and high-resolution movies.

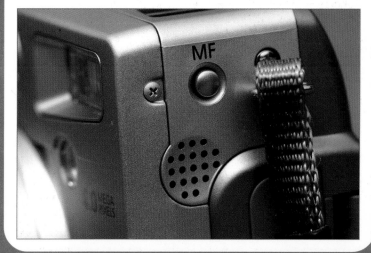

27

The video jack found on digital cameras allows you to plug your camera directly into your television. This enables you to preview your images directly on your television screen.

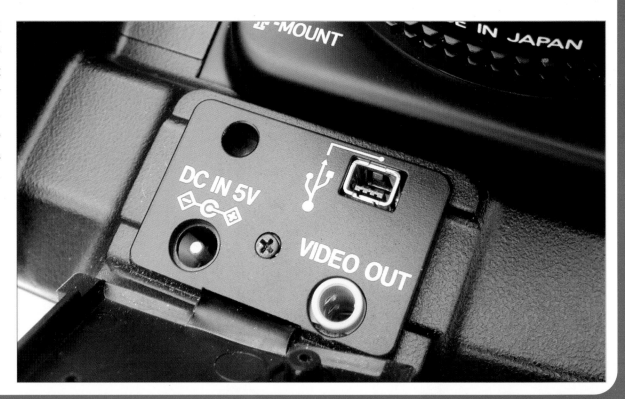

28

Digital cameras use a wide variety of batteries from NiMH (Nickel Metal Hydride) to proprietary Lithium Ion battery packs designed especially for your digital camera. These proprietary batteries are either charged in the camera when in its docking station, or with chargers designed for that specific battery. If you travel and take plenty of images, you should have at least one extra set of batteries.

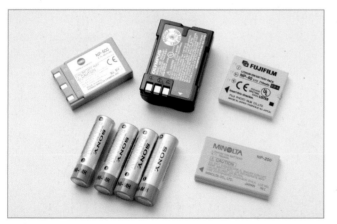

29

The lens cap is a critical part of a digital camera system as it protects the fragile front lens element. Most digital cameras have their own special lens cap that attaches directly to the camera or camera strap for safekeeping. Some of the smaller digital cameras have a built-in lens cap that slides over the camera lens when it is not in use.

30

One of the biggest problems photographers encounter when taking pictures is camera movement. This is often because the photographer does not hold the camera properly. You really need to hold steady when you take a picture; otherwise, your photos will be blurry. Your camera can accidentally move because you jiggled your arms—or your whole body—when taking the picture.

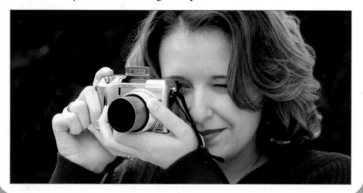

31

When you first pick up your digital camera, position it in your hands in a way that feels comfortable. Since digital cameras are so compact, it is easy to get your fingers or camera strap in the way of the lens or flash. Before taking a picture, make sure that these areas are not obstructed.

32

Hold the camera snugly to your eye to view your image when using the optical viewfinder. Position your right index finger over the shutter button. By pressing the shutter button down halfway, the camera will activate the autofocus function and stand ready for when you fully press the button. This prefocusing helps shorten any shutter delay.

As you take the photo, hold your breath and gently squeeze the shutter button to avoid any camera movement. If you push the shutter down rather than squeeze it, you will move the camera and blur your photos.

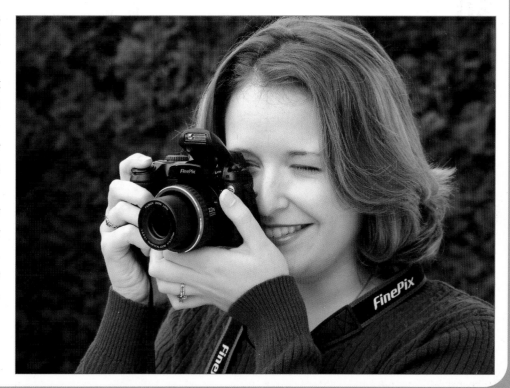

33

You can also use the LCD viewer on the back of the camera to compose your photo from a distance. This same viewer can be used to review the photos you have taken to be assured your exposure and composition were correct. This is a big advantage of digital over film.

34

Most photographers tend to take horizontal images. However, there are some scenes that should be recorded vertically. Learn to take two images, one horizontal and one vertical. To take a vertical photo, hold the camera firmly against your forehead, and cradle the lens using your left hand to provide firm support.

35

It is difficult for photographers who wear glasses to achieve proper viewing using the optical viewfinder. It is possible to buy special corrective lenses and place them in the eyepiece. An alternative is to use the LCD viewer on the back of the camera.

36

Several of the digital cameras feature a diopter correction mechanism so you can dial in your exact prescription and accurately focus through the viewfinder without your glasses. This diopter correction is usually located next to the optical viewfinder on the camera.

37

When taking pictures, you must hold still to avoid camera movement. The best way to do this is to steady yourself like a camera tripod. If you stand on one foot, you will find yourself very wobbly. When you plant both feet on the ground close together, you still sway from side to side. The best bet is to slightly spread your feet to maintain your balance and provide a steady platform for your camera. Be sure to place your elbows snugly against the side of your body so you can firmly hold the camera with two hands.

38

When you are ready to take the picture, hold your breath and gently squeeze the shutter to obtain the sharpest image.

39

You can also brace yourself against a wall for added support and to help stabilize the camera.

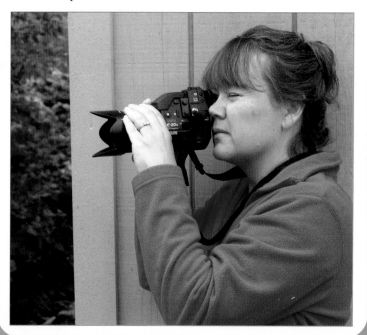

40

Even a fence can be used to help minimize camera movement. As you hold the camera, set one hand on the fence to cushion the camera and provide added support.

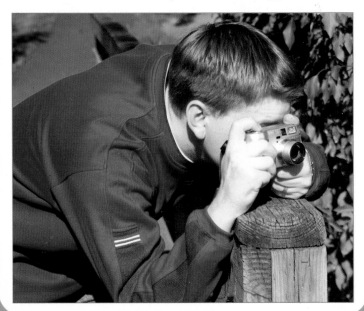

41

Try different positions, such as crouching, to help stabilize the camera. This lower position also provides a different perspective to your photos.

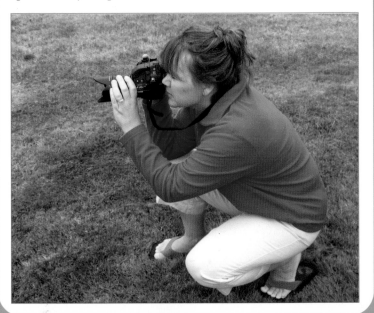

42

A tripod is an important piece of equipment; it provides a stable platform and minimizes camera movement.

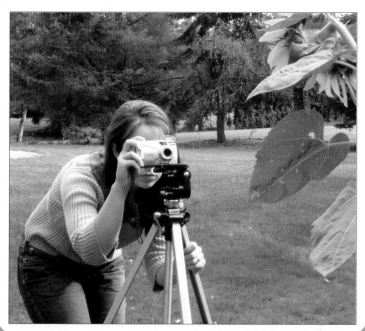

43

Most tripods have legs that can be extended to provide added height.

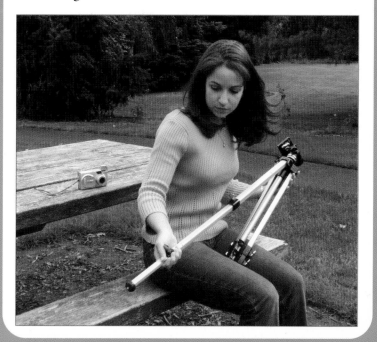

44

Be sure to attach the camera securely to the tripod using the tripod socket located on the bottom of your camera. Take care not to overtighten this screw, as digital cameras are delicate instruments.

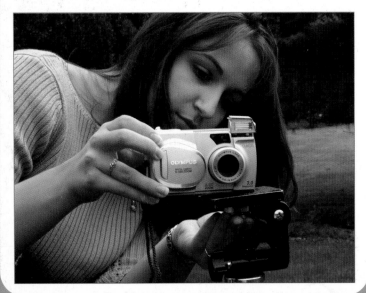

45

Once the camera is attached to the tripod, use the optical viewfinder to frame your subject. Once you have taken a picture, you can review it on the LCD viewer, and then make any modifications before taking another image.

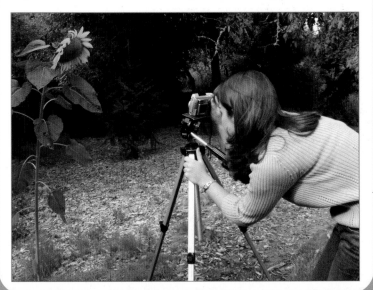

46

When taking long exposures, you can use a cable release to minimize any camera movement while you depress the shutter. Some of the more sophisticated cameras have connectors on the back of the camera that accept electronic cable releases. However, this option is not available on all cameras.

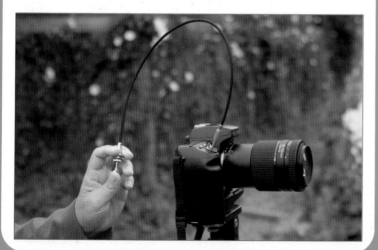

47

Some digital cameras have a remote control function that allows you to zoom the lens and fire the shutter while working from a distance.

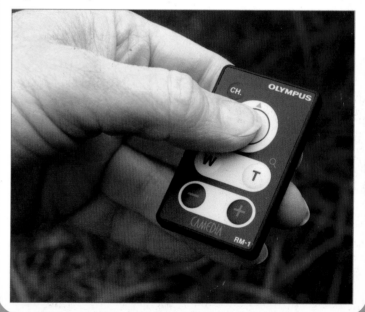

48

Digital camera instruction books are often confusing to beginners. Manufacturers realized this problem, and most now package a "Quick Start" cheat sheet with the camera to simplify the process.

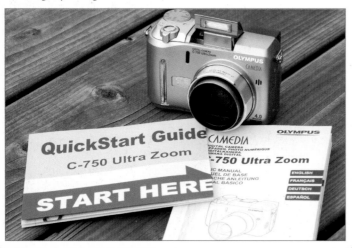

49

One of the first things you should do with your digital camera is to lay out all the parts and familiarize yourself with them. When you locate the compartment for your memory card, open the door and carefully insert the card, following the direction indicated by the arrows.

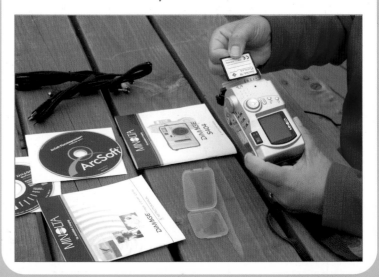

50

Digital cameras consume a tremendous amount of power. If you try to use alkaline or NiCad batteries, you may find that even brand new batteries will give a low battery warning. We recommend the use of Ni-MH (nickel metal hydride) batteries of at least 1600 mAh (milliampere hours) to power your camera. Get two sets so you always have charged batteries ready to go. Be sure not to mix batteries of different amperage.

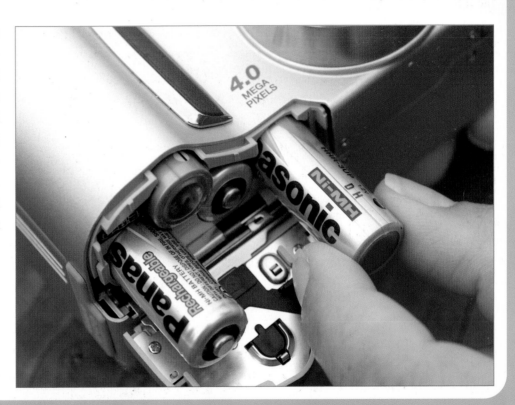

51

When you insert the batteries into your camera, you will notice that there are + and – markings that indicate how the batteries should be inserted into the chamber. If the batteries are not inserted correctly, your camera will display error codes or will not work at all.

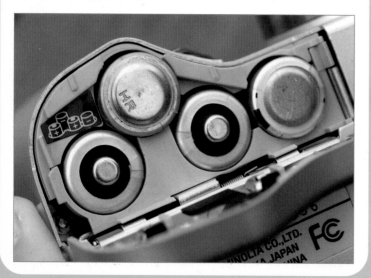

52

Before you take your first picture, you must set up a few functions in the menu. The white balance should be set to auto so the camera will automatically select the correct color balance. If you ever need to photograph under unique lighting situations, such as tungsten or fluorescent, this is where you would change the color balance to compensate.

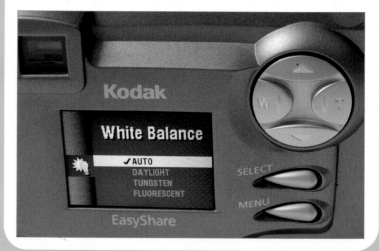

53

The ISO menu should also be set on auto so the camera can make the necessary adjustments as the light level changes.

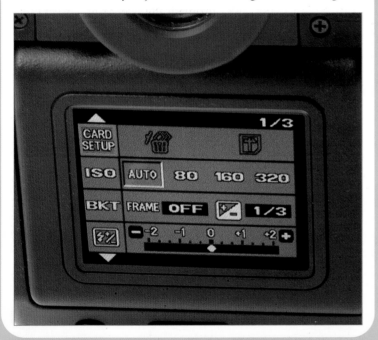

54

Normally, you should leave the sharpness menu at its default setting, which is somewhere in midrange. As you become more familiar with your camera, you can start experimenting. You can also turn the sharpness off and sharpen your images later using your photo editing software.

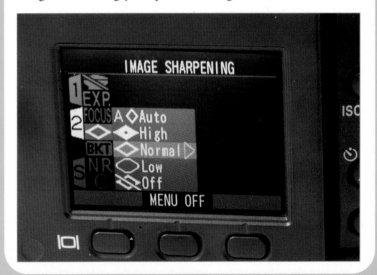

55

The exposure compensation menu should also be set to zero so the camera uses the ISO speed set on the camera. When you get an over- or underexposure, you can then modify this setting to make the correction necessary to achieve a good exposure.

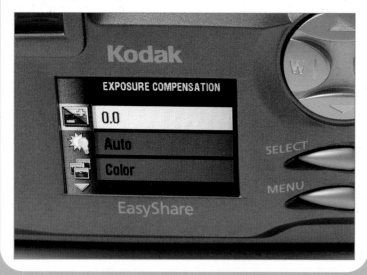

56

Two additional controls found on some of the more sophisticated digital cameras are the saturation and contrast controls. Leave these at the default setting until you feel confident using your digital camera. If you ever wish to revert to the default mode, but can't remember what the settings are, you can go to the "reset to default" menu, and the camera will revert to its factory defaults.

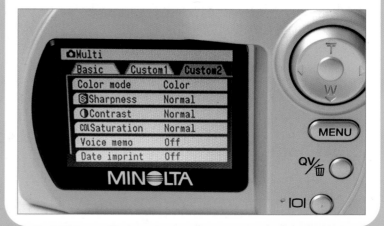

57

On the top of most digital cameras you will find the exposure mode control. Most will feature program (P), aperture (A), shutter (S), and manual (M) controls. Some of the more advanced cameras may also feature sports (runner icon), portrait (head profile icon), landscape (mountain icon), and close-up (flower icon) modes.

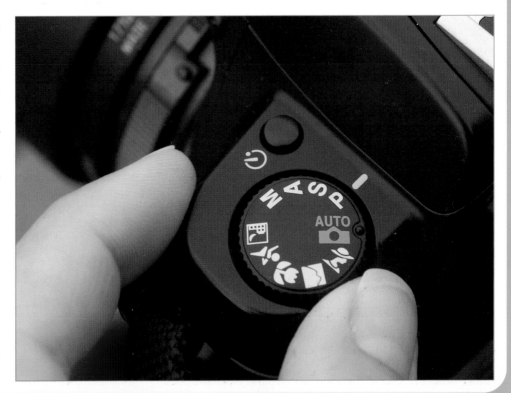

58

The biggest advantage with a digital camera is that once you have taken your first picture, you can preview your results on the LCD viewer to ensure that it was taken correctly. If your image was poorly framed, improperly exposed, or the focus was off, you can then make the necessary corrections and take another picture.

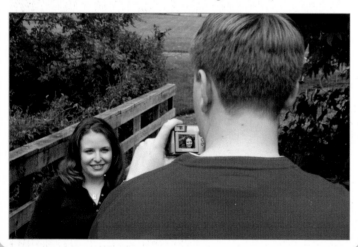

59

The zoom control on the digital camera allows you to capture just a small segment of the picture or encompass the entire scene, without moving closer or further from the scene.

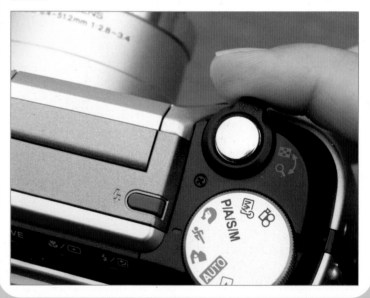

60

The best way to tell a story with your photos is to capture the essence of the scene by using the wide-angle portion of the zoom lens. By toggling the zoom control to W on the point & shoot cameras or manually zooming your SLR camera lenses, you can determine the widest focal length of the lens.

61

Once you have taken a few wide-angle photos, try zooming in a bit to capture a different perspective with the normal lens setting.

62

Photos take on a completely different feel when you zoom in to capture the action.

63

The key to taking good digital pictures is to take plenty. Since you no longer have to worry about the expense of processing and printing, you can take as many exposures as you need to get the image right.

64

Once you have taken a picture, you can use the zoom function in the LCD display to zoom in on your image to see if anyone closed their eyes or if the image is not sharply focused. If everything looks good, then keep on taking pictures. If not, make any necessary modifications and try again.

65

The digital memory card is the digital equivalent of film. There are more than half a dozen types used in digital cameras today. They include the CompactFlash card (upper left), Smart Media card (upper center), Memory Stick (upper right), SD card (lower left), XD card (second from lower left), MultiMedia card (third from lower left), and the PC card (lower right).

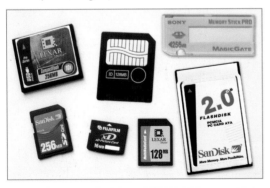

66

The megabyte rating found on the front of each card indicates the amount of data the card can hold. The rule of thumb is that the card's capacity for recording images matches its megabyte rating. For instance, this 64MB (megabyte) CompactFlash card will hold approximately sixty-four images at normal resolution.

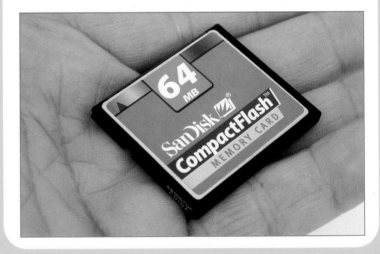

67

Memory cards are fragile and can be easily damaged. These protective holders often come with the purchase of the card and should always be used when the memory card is not in the camera.

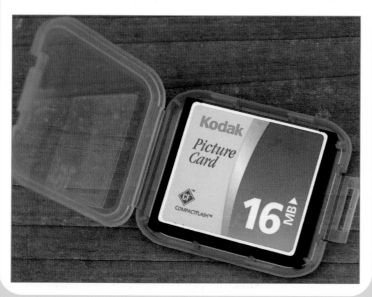

68

Pictures from your camera can be transferred from your memory card into your computer in several ways. The most common method is by purchasing a card reader. When you insert your memory card into the reader, the images are immediately transferred into your computer. Once they have been saved on your computer's hard disk, the data on the memory card can be deleted, and the card will again be ready for use in your camera.

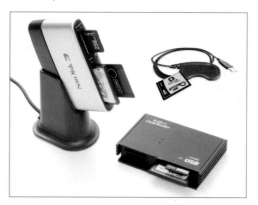

69

There are a few digital cameras on the market that use a docking station for image transfer, charging batteries, and even output to small prints. The docking station connects permanently to your computer via a USB or FireWire connection. When you need to transfer images from your camera, simply place the camera in the docking station and your pictures will appear on your computer screen or output to printing paper.

70

If you are going on vacation and don't have enough memory cards to last the entire trip, don't panic. There are portable hard disks from 10G (gigabyte) and up (left) that can download your images for later transfer to your home computer. Once you have verified that your images have been safely transferred to this portable unit, you can delete the images on the memory card and continue taking photos. More recently, a new type of CD burner (right) is available that doesn't even require a computer. You can download your photos to a CD and verify that the transfer is complete before deleting the images on the memory card.

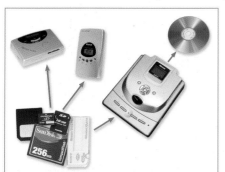

71

Another method of image transfer is via a PCMCIA (Personal Computer Memory Card International Association) adapter found in most laptop computers. Simply load your CompactFlash or Smart Media card into this adapter (which fits into a slot on your laptop computer), and the images are transferred to your laptop.

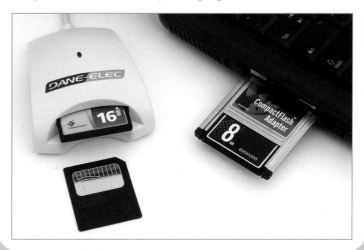

72

The size of the digital file on your memory card will be determined by the file compression and the actual resolution of the file. The resolution of the file should be left at the default setting, which is the highest resolution that the camera can support. The default for the compression will be in the middle of the JPEG (Joint Photographic Experts Group) scale.

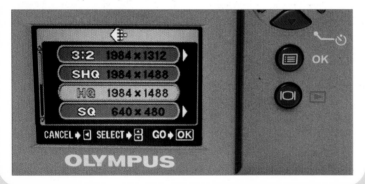

73

The megapixel resolution of a camera will determine the quality of the final image. Today, 3–4-megapixel cameras are common, and will produce high quality 8 x 10-inch color prints. Some of the newer camera models feature resolution in excess of 6 megapixels. Remember, the higher the megapixels, the higher quality the image.

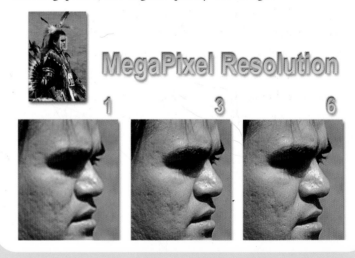

74

File compression determines the size of the file and the quality of the image. The higher the compression, the smaller the file—but the lower the image quality. Lower compression yields a higher quality image and a larger file size. As you increase your image quality, you get fewer images on your memory card. This is why you may want to invest in several memory cards so you won't have to sacrifice image quality. Remember, the lower the compression, the higher quality the image.

JPEG File Compression

High **Medium** **Low**

75

With digital cameras, the ISO setting changes the camera's CCD chip's sensitivity to light. Unlike film cameras, the ISO of the digital camera can be changed from one frame to the next. The ISO button is usually located on the top, back, or side of the camera.

76

Once you press the ISO button, you will be presented with a menu screen that will allow you to select auto or the various speeds that the camera supports. You can use the menu toggle to make your selection.

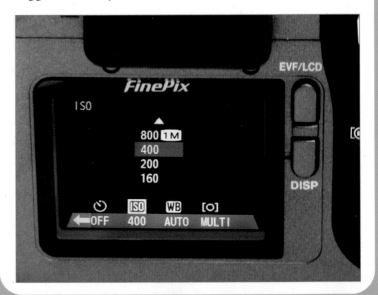

77

Lower ISO settings like ISO 100 can be used for photos when you have plenty of light or if you use flash. This setting gives you the maximum quality possible with your digital camera.

78

As your light level drops or your photo situation requires more depth of field or a higher shutter speed, you can increase your ISO to 400.

79

Many of the more advanced digital cameras support ISO settings up to ISO 1600. With high shutter speeds, you can capture extreme action and freeze the moment.

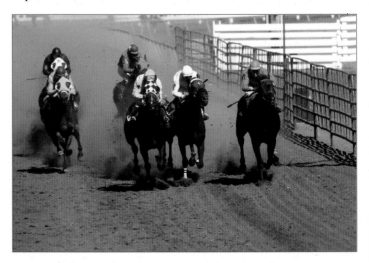

There is a delay that occurs between the time you press the shutter button and when the actual picture is taken. To decrease this lag time, you can press down halfway on the button, and the camera will prefocus on the subject. When you are ready to take the picture, gently squeeze the shutter button, and the image will be recorded.

81

If you are having trouble focusing on your subject, many cameras have a switch that allows you to change from auto focus to manual focus. When using manual focus with the digital SLR camera or zoom reflex, you rotate the lens barrel to achieve accurate focusing. With some point & shoot cameras, you can use a menu to manually modify your focus. The new image is displayed in the LCD viewer, along with a numerical readout of the distance.

82

When using the optical viewfinder on a point & shoot camera, you may find that what you see in the viewer is not what the camera records. This is because the camera lens and optical viewfinder are not in a direct line with each other, so they each see different portions of your scene. (This is referred to as *parallax*.)

Normally, this is not a problem with wide-angle photos, but it becomes critical when taking close-ups. This problem can be corrected by aligning your subject within the parallax correction lines in the viewfinder. It may look strange and off-center, but the image will record properly.

83

The LCD viewer allows you to properly frame your subject, even when taking close-up photos.

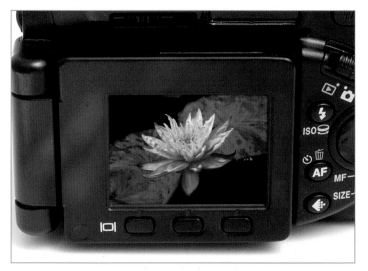

84

The two controls that adjust your exposure with a digital camera are the aperture and shutter speed. The shutter speed is usually adjusted by pressing the function button to shutter control and turning a dial on the top of the camera. Your shutter speed selection is then displayed in both the viewers on the back and top of the camera.

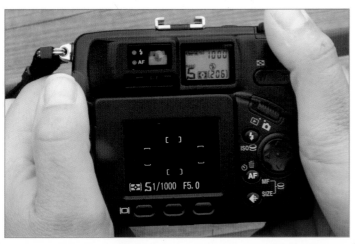

85

The aperture is adjusted by pressing the same function button again, turning it to aperture control, and rotating the same dial as was used to adjust the shutter speed. This time, the various selections are displayed in the top LCD viewer and on the LCD preview screen on the back of the camera.

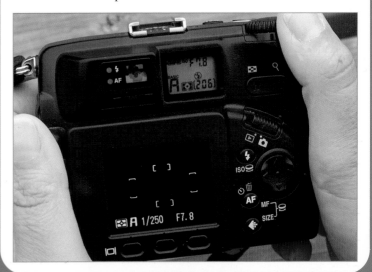

86

When the light level drops, or when you are taking pictures indoors, you will need to open the aperture and decrease your shutter speed in order to capture the scene. In this case, we braced the camera on a seat and used ⅛ second at f4 to highlight this music ensemble.

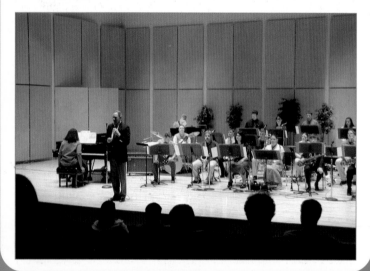

87

When taking action photos outdoors, you will need to keep the shutter speed as high as possible to stop the action. To achieve a good exposure, you will need to adjust the aperture to a wide setting to allow for an increase in shutter speed. Remember, the higher the shutter speed, the more the action is stopped. For this photo, we used ¹⁄₁₀₀₀ second at f5.6 on a zoom lens.

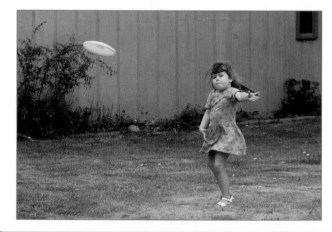

88

Here is a correctly exposed photo taken with a slow shutter speed and a small aperture. This image conveys a feeling of motion because the slow shutter speed didn't stop the action. The shutter speed for this photo was $\frac{1}{15}$ second at f22.

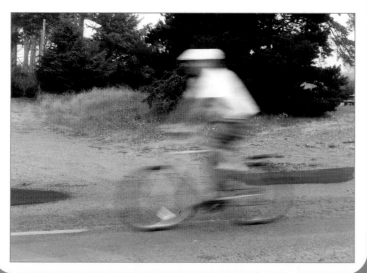

89

To create this image, we opened the lens up to f4, which then increased the shutter speed to $\frac{1}{500}$ second. This combination gave us a good exposure and also stopped the action.

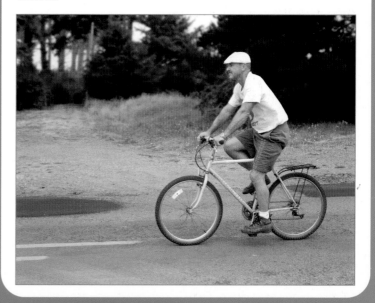

90

On an SLR digital camera, you will find the same basic adjustments as on a traditional film camera. The interchangeable lens features an aperture ring and focus control.

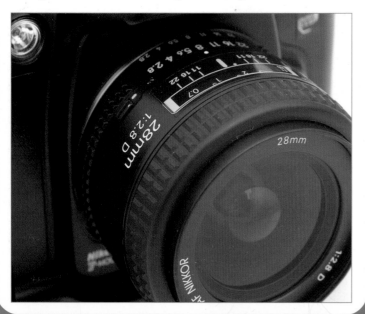

91

The top of the SLR lens features several numerical scales. In the window you will see the focus distance displayed in meters and feet. Below that, you see a line indicating your point of focus. The f-numbers on either side show you the depth of field, or area that will be in focus at a given f-stop. You will find the aperture selection at the back of the lens where it joins the camera. On many of the newer cameras, you would lock the lens to the smallest aperture (f22 in this case); the aperture selection is then accomplished by rotating a dial on the camera itself.

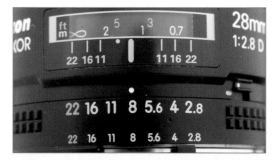

92

The aperture or f-stop controls the amount of light that enters the lens. A large opening allows plenty of light, while the smaller opening restricts light. The large opening will have a small number like f2.8, while the smaller opening has a large number like f22. Confusing, huh?

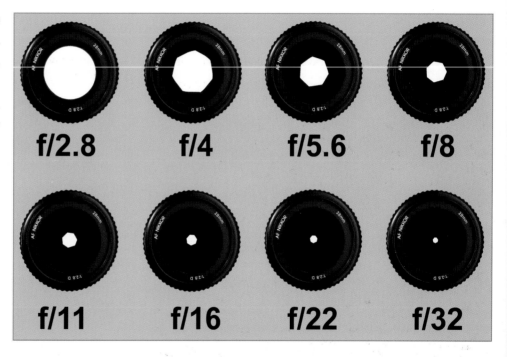

93

As each f-number changes from one full f-stop to the next, the light is cut in half. Stopping down from f4 to f5.6, for example, reduces the amount of light coming through the lens by one half.

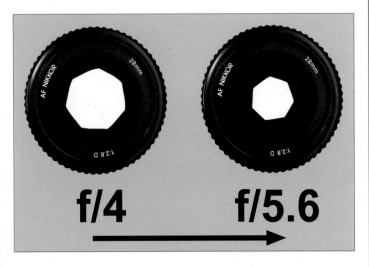

94

When you reverse directions and go from f5.6 to f4, it doubles the amount of light reaching the CCD chip in your digital camera.

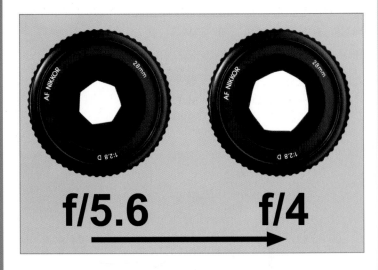

95

To give you a better idea how this theory actually works, we set our lens to f2.8. This is a wide opening that allows lots of light to enter the lens. The problem here is that when you use a wide f-stop, your depth of field, or area of the image that will appear in focus, is reduced.

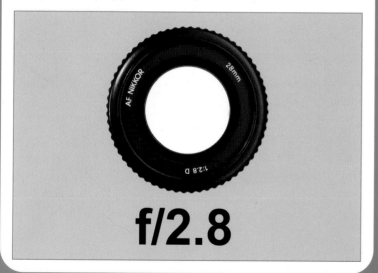

96

We focused on the fifth domino and shot the image with the lens at f2.8. You will notice that the areas in front of and behind the fifth domino are out of focus. This image shows you the depth of field that results when your lens is set at f2.8.

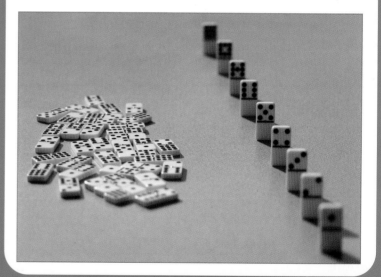

97

For this image, we changed our f-stop to f32 so that very little light enters the lens. Because we used a smaller f-stop, more area in the photo is in focus.

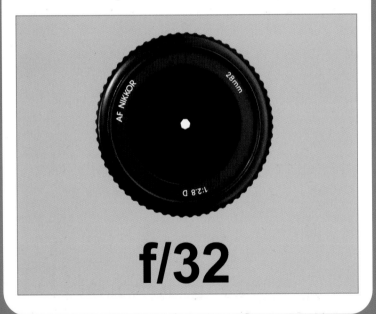

98

Here we have again focused on the fifth domino, but you can see that all the dominos, from the first to the ninth, are now in focus. The smaller aperture of f32 allowed less light but produced maximum depth of field.

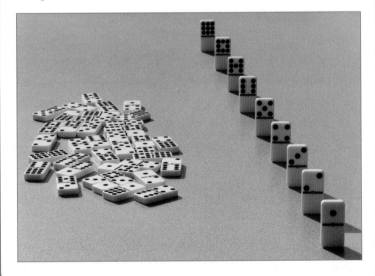

99

When taking your first digital photos, you will want to set your camera to the program (P) mode. This allows your camera to set both the shutter and aperture for you. For general photography in sunlight, the program mode works great. Here we used $\frac{1}{250}$ second at f11.

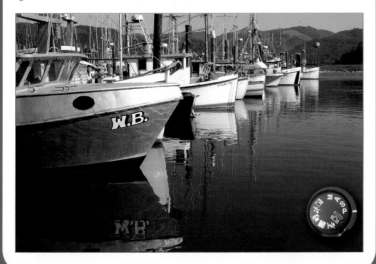

100

When the shutter (S) mode is selected, the photographer can select a specific shutter speed and the camera will decide the aperture necessary to obtain a good exposure. The advantage here is that you can control the action based on your shutter speed selection. In this photo, we used $\frac{1}{1000}$ second at f5.6.

101

In the aperture (A) mode, the photographer has full control over the depth of field via the f-stop selection. This feature is especially great for macro photography where you need maximum depth of field.

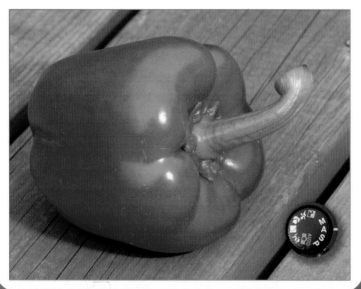

102

Sometimes the program, aperture, and shutter modes may not provide a correct exposure. Generally, this occurs in mixed lighting conditions. Here, a fog bank had rolled in on the coastline and filtered the sunlight. Metering for this lighting was difficult, so we switched to manual (M) to make our own aperture and shutter speed selections. We used $1/200$ second at f8 for an accurate exposure of the scene.

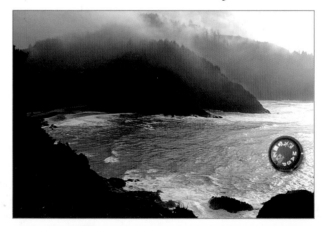

103

Some of the more advanced digital cameras feature additional exposure modes. In the sports (runner icon) mode, the camera uses high shutter speeds to stop the action. If the light level drops, the camera will lower the shutter speed to achieve an accurate exposure. The camera will always use the highest shutter speed possible, but will not compromise a good exposure in the process.

104

In the portrait (head profile icon) mode, the camera will set the lens approximately at two stops from wide open and adjust the shutter speed accordingly. This provides good depth of field for the portrait, but will cause the background to be subdued.

105

If your camera has a close-up (flower icon) mode, it will select small f-stops in order to provide maximum depth of field for your photos.

106

The landscape (mountain icon) mode provides a small f-stop so you can keep your wide-angle photos all in focus. It also accounts for the fact that you need a high enough shutter speed to maintain image sharpness, so it usually selects an aperture 1 to 2 stops down from maximum.

107

Advanced amateurs and professional photographers sometimes rely on hand-held exposure meters to solve complicated lighting situations. These complex instruments have LCD digital readout, push-button controls and can analyze both available light and electronic flash. Two types of metering are possible with a handheld meter—incident and reflective. With incident metering, the meter is held in the same light as the subject with the white dome pointing toward the camera. When the button is pressed, the meter correctly reads the amount of light falling on the subject and indicates the correct f-stop and shutter speed selections for your camera.

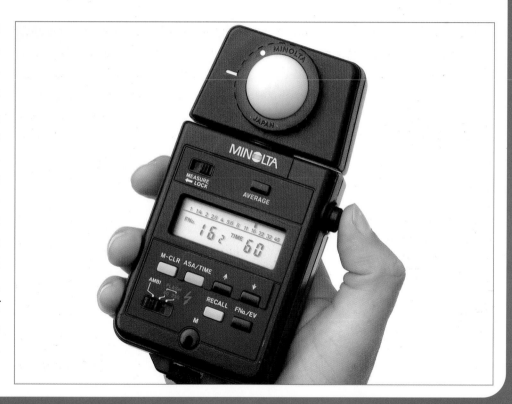

108

The reflective metering system works like the one in your camera, but it is more accurate. There is usually a small spot attachment to your handheld meter that, when pointed at your subject, provides an accurate readout of the amount of light falling on small areas of your photo. This is a much more accurate method since it can analyze smaller areas than is possible with your camera meter.

109

The camera lens will focus the light through the aperture onto the CCD chip in the digital camera. In point & shoot cameras, there is one lens that provides different vantage points from wide angle to telephoto by the simple zoom movement of a switch. The focus of the lens is accomplished by the autofocus system in the camera.

110

The digital SLR camera allows you to change lenses. With these cameras, photographers have a variety of lens types—from fisheye to extreme telephoto—available right at their fingertips.

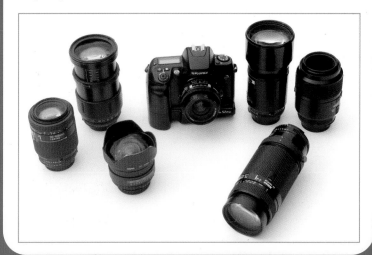

111

The biggest difference between digital and traditional SLR cameras is that the CCD chip inside the digital camera is smaller than the traditional 24 x 36mm film frame. This means that the digital image is magnified between 1.4 and 1.6 times. For example, a 100mm lens would become approximately 150mm on digital, and a 300mm lens would become 450mm. CMOS SLR cameras generally do not have this problem and take the same image size as SLR film cameras. The photo here illustrates the magnification ratio of the digital CCD SLR vs. the film SLR camera image.

112

This image depicts a digital SLR camera's lens range from 14mm to 500mm. As you can see, when you increase your focal length (use a longer lens), you move in closer on the subject. The point & shoot system uses different factoring when determining lens focal lengths. If you want to compare the two, you will need to multiply your point & shoot lens's focal length by 5.55 to determine its equivalent in a digital SLR camera. For example, a 10mm point & shoot lens is about equal to a 55mm SLR lens.

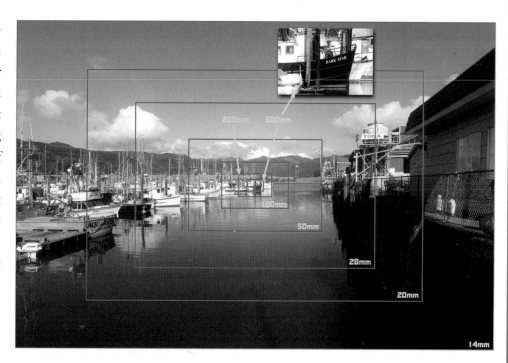

113

Here we see that a wide-angle lens creates a distorted image, but it provides extreme depth of field.

114

By keeping the image size the same but using a telephoto lens, the image is compressed and looks normal, but the background is diffused due to the larger aperture.

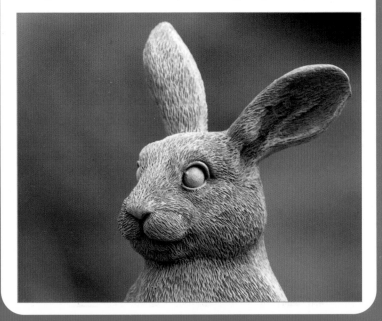

115

Wide-angle lenses can add perspective if you place something small in the foreground and have large objects in the background. When you move close to the foreground object and use a small f-stop (f22) you will achieve maximum depth of field in your photo. This gives the illusion of the foreground object being the same size as the larger object, thus creating perspective in your photo.

116

The telephoto is used to bring your subject closer without you having to change positions. It also compresses the distance between objects so that the one closest to the camera feels as if it is right next to the distant subject.

117

Many of the more advanced point & shoot digital cameras will accept a wide variety of accessory lenses. These range from fisheye to telephoto and will expand your picture-taking capabilities. Here we see a wide-angle converter lens being attached.

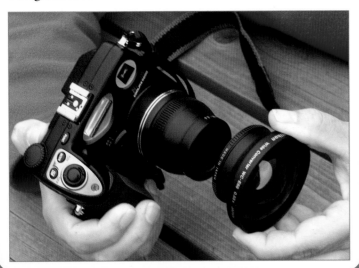

118

Sometimes you can just attach the lens and you're ready to go. Other times you may have to go into the menu mode and tell the camera that you have attached an auxiliary lens; otherwise, the camera will not focus the image correctly. Here we see the telephoto converter lens being attached.

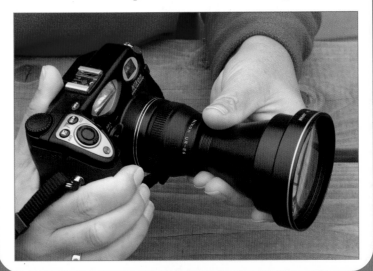

119

Many of the digital SLR lenses will have a tripod socket that will reduce the strain on the tripod socket located on the bottom of the camera body.

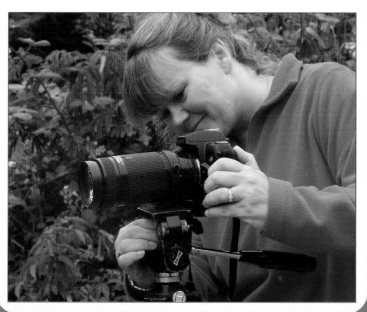

120

One of the best features of the digital point & shoot camera is its ability to allow you to take close-up pictures. You can use either the optical viewfinder or the LCD viewer on the back of the camera to compose your image. Remember to consider the problem of parallax viewing when using the optical viewfinder. (See frame 82.)

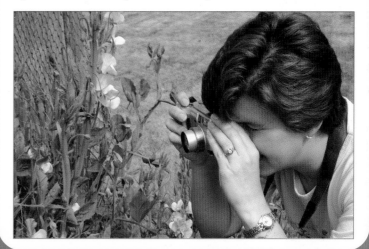

121

After you have taken a picture you can view your results on the LCD viewer to ensure that you have taken the picture properly. Some of the digital cameras allow you to magnify your recorded image so you can check on the degree of focus or depth of field in the picture. If you have trouble viewing your recorded image in sunlight, move to a shady spot to review your images.

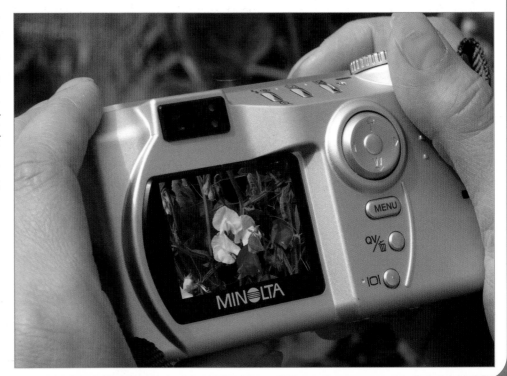

122

If your close-up images require extreme depth of field, the required shutter speed may be too low to handhold the camera. You should then mount your camera to a tripod for added stability.

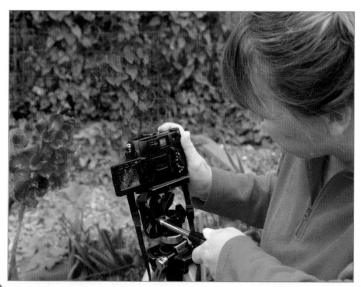

123

Once you have taken your image using the macro or flower mode on the camera, you can view your results on the LCD screen. If you have trouble viewing the screen in sunlight, cup your hand around the viewer to shield the glare.

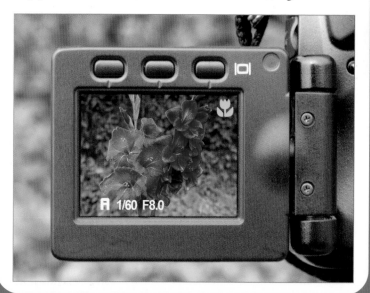

124

Most of your pictures will be taken in available light without the aid of an electronic flash. Since digital cameras work well in low light situations, you will find that you can take indoor available light photos with your digital camera, whereas a film camera image would have required flash.

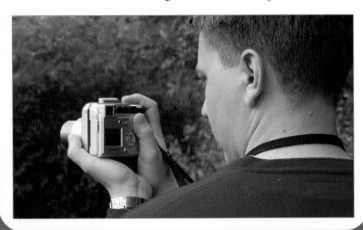

125

Pictures taken in bright sunlight provide the option of both a high shutter speed and good depth of field because of a small aperture. This gives you the best of both worlds as everything is in focus and correctly exposed.

126

Just because the sun is hidden behind a cloud doesn't mean you should put away your camera. Overcast days provide some of the best color saturation possible. The soft lighting diffuses the shadows, and you still have enough light to keep the image sharp with high shutter speeds.

127

As you venture into the deep shade, light levels drop. You will need to increase your ISO to make the CCD chip more sensitive to the light. You can even vary your ISO from shot to shot. In order to achieve a good exposure, you should lower your shutter speed or open up the lens to allow more light to strike the chip. You may even need a tripod to keep your image sharp at a low shutter speed.

128

Digital cameras also work quite well indoors under low light situations.

129

As much as camera exposure systems have evolved, there are certain lighting situations that can fool the best of them. When the sun peeks around the subject, an underexposure can occur.

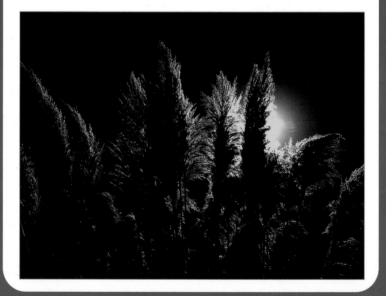

130

Many digital cameras feature an exposure lock button that allows you to point the camera away from direct sun and lock in the correct exposure reading. When you return to take the picture, the camera will use the exposure you set and expose the image correctly.

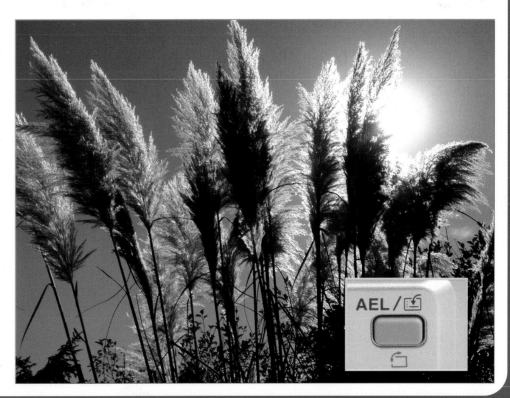

131

When the light level gets too low, you will need to use an electronic flash. Most digital cameras feature an internal flash unit.

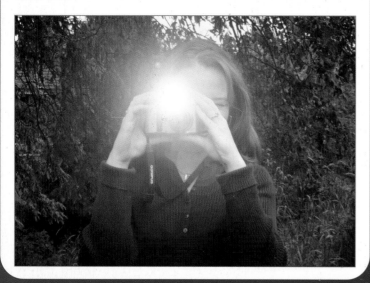

132

The internal flash is designed to work directly with the exposure system inside your camera. This makes it easy to take flash pictures, but because the flash is close to the lens, it creates a harsh light that can often cause red-eye.

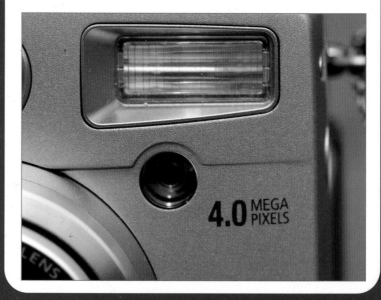

133

Sometimes when you take a flash picture using your digital camera, an under- or overexposure occurs. On most digital cameras there is a flash compensation feature. This allows you to add or decrease exposure for any subsequent flash pictures. You will have to search for this compensation control as it can either be a button on the camera body or included in the menu function.

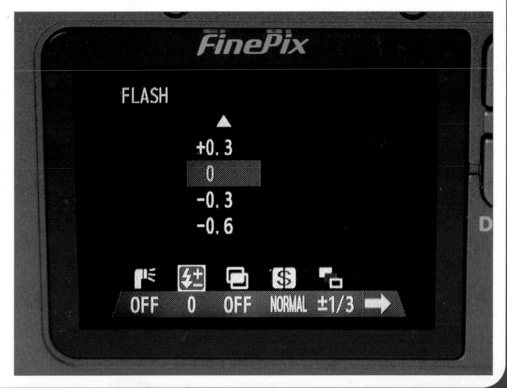

134

The internal flash in your digital camera has several variations. The auto flash (auto and lightning bolt icon) allows the camera to decide when and when not to activate the flash. For example, when you take pictures in sunlight, the flash will remain off. When you move into the shadows, the flash will sense if the light is too low for you to steady the camera and will fire.

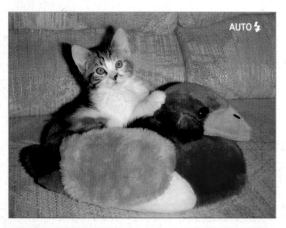

135

In some cases room light may be strong enough that the camera flash will not activate. In this situation, you must disable the auto flash and switch to the flash always on (lightning bolt icon) mode. In this mode, the flash fires every time you press the shutter button—whether the camera thinks it is necessary or not.

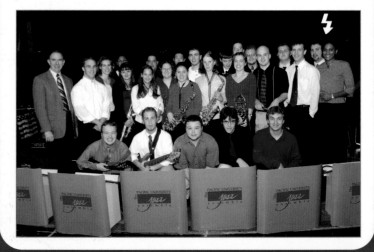

136

When you take a photo using the internal flash you will sometimes get red-eye. This occurs because the human eye dilates in low light to allow the iris to see. When you fire the flash, the iris doesn't have enough time to close down, so the light bounces off the retina, causing the red-eye effect. Some of the digital cameras feature a red-eye reduction flash (eye icon) feature that fires short bursts of light prior to the final flash. This allows the eye to adjust before the final image is taken.

137

If you find a hotshoe on top of your digital camera, then you will have the ability to add an auxiliary flash unit. The versatility of the hotshoe depends on how many contacts it has. Two contacts are for manual flash, while more contacts mean more flash control.

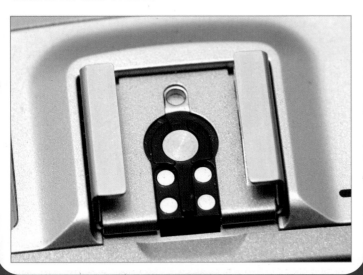

138

Here we see a photographer using an auxiliary flash (mounted on the hotshoe) to take the picture. She can then review her results using the LCD viewer.

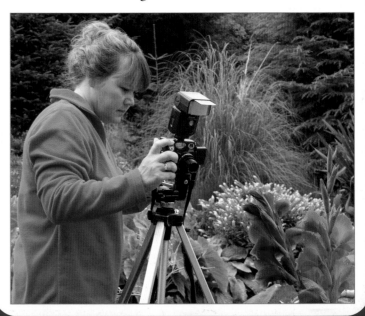

139

You can also attach a flash sync cord to the camera hotshoe and the external flash unit. This allows you to move the flash away from the camera and lens to achieve more variety in your lighting.

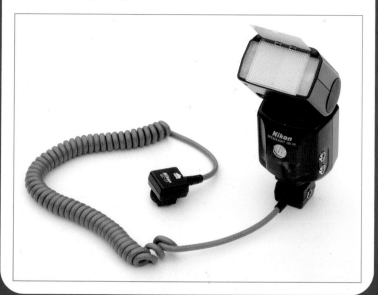

140

Here we see a photographer using the auxiliary flash held at a 45-degree angle to the flowers. This provides nice side lighting not possible with the internal flash.

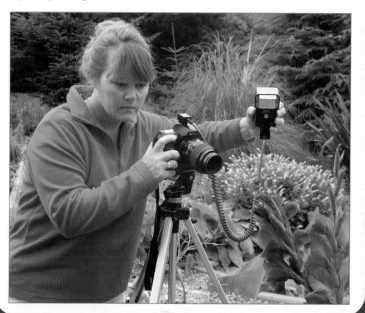

141

The auxiliary flash can be positioned to bounce light off the ceiling or wall because of its ability to tilt and swivel.

142

For this photo we mounted the flash directly on top of the camera. Notice the harsh shadows created by the direct flash.

143

We then positioned the same flash so that its light bounced off the ceiling to provide a much softer, diffused light.

144

Some external flashes come equipped with diffusion material that slides down over the flash head or allows the flash to bounce off it to create soft lighting. This works well when the ceiling is too high to use for bouncing the flash or when the wall's tint would dominate the photo.

145

Sunlight can also create harsh lighting. When the sun is positioned behind your subject, his/her face often appears shaded and dark.

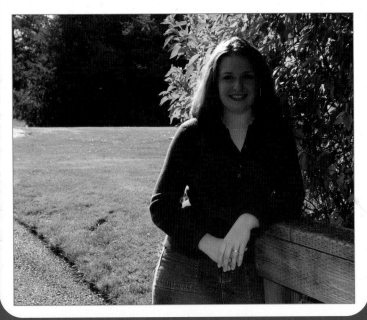

146

To avoid this, set the internal flash to flash fill. This forces the internal flash to take a picture even though you are in full sunlight. The shadow area is then filled with light and balances with the sunlit area behind the subject. You can also use auxiliary flash to fill in the shadows.

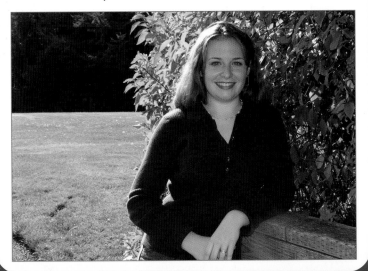

147

Most external flash systems will have four exposure controls. The TTL function means that the flash and camera are dedicated to work together to create a good exposure. The stroboscopic mode (multiple lightning bolts icon) fires multiple flashes during one exposure to create special effects. The manual (M) mode allows you to set the flash to any variation of power usage such as full, half, or quarter power. Finally, the auto (A) function is selected when the flash and camera brands do not match, so that the flash will determine the exposure independently.

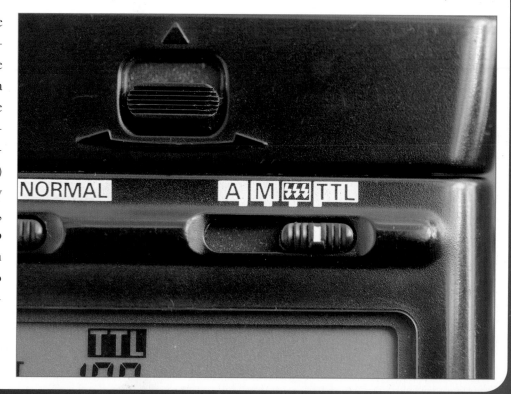

148

This image shows the back of an LCD panel of a typical external flash unit. You will see that the ISO is set to 100 and it is in the TTL mode. The flash senses the focal length of the attached lens and sets its range to match the lens coverage. The scale in the middle of the window shows the working range of the flash at f2.8. In this instance, it will provide a correct exposure from 6 to 60 feet.

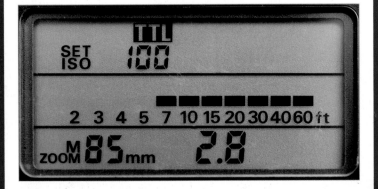

149

As long as you photograph a subject that is within the distance indicated on the flash, you should get a good exposure. Because the electronic flash puts out a burst of light of such short duration, it is the perfect solution for stopping high-speed action.

150

When you view a photo, there is a distinct reason why you like it or don't. This is because of composition, the way the subjects in a photo have been arranged. There are no clear-cut rules as to the right or wrong way to compose an image, because everyone sees things differently. However, in this chapter we will offer a few suggestions that can be used to improve your composition and add impact to your images.

151

To vary perspective in a photo, change your camera angle. Some of the newer digital cameras have an LCD viewer that flips out away from the camera and even rotates. This works great for taking those high angle photos. Just turn the viewer so you can see the image even when the camera is held high above your head.

152

Sometimes the normal view works well too.

153

To obtain low angle views, you can set the camera almost on the ground and rotate the viewer so you can compose your picture without even having to crouch down.

Even if your camera doesn't have a rotating viewer, you can take a low angle photo and review it with the LCD viewer to see if you captured the image you had in mind.

154

Many times photographers do not pay attention to what is going on in the background. Take time to scrutinize the image in the viewfinder to see if there is anything distracting your eye away from the subject. As you see, this beautiful flower is being dominated by the plants in the background. It is hard to keep your eye centered on the flowers when there is so much to look at in the background.

155

By using a large aperture, the background is thrown out of focus and is no longer distracting.

156

The zoom feature is a nice function. It lets you take multiple views without moving. When you see a beautiful scene, be sure to take an overall wide-angle view.

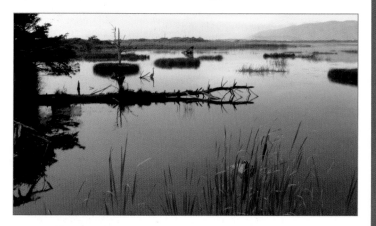

157

You can then zoom in and capture a different mood or subject. When you do, you will find that your photos take on a whole different composition.

There is some confusion with the digital vs. optical zoom. The digital zoom only crops the image; it appears larger, but is lower in quality as seen in the image on the left. Keep in mind that the optical zoom actually increases the physical magnification of the image, so you can expect high-quality results as shown on the right.

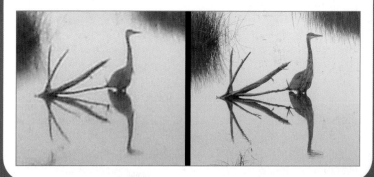

158

Beginning photographers often position their subject dead center in the photo. Sometimes this might provide good composition, but maybe not the best form.

159

If you were to superimpose four lines across your photo—two horizontal and two vertical—the image would be divided into thirds. An important compositional theory, the Rule of Thirds, dictates that you will create a more pleasing composition if you place your subject at one of the four points where these imaginary lines intersect.

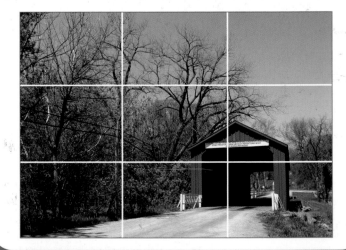

160

One of the most dramatic forms of composition is where lines lead to a point. Generally, the lines start at a corner of the photo and lead out to one of those points we just mentioned. This type of composition is even more powerful when you have a subject at the end of the line.

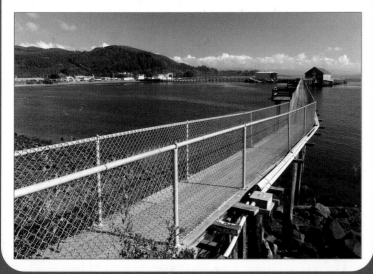

161

Another powerful composition is when you photograph similar objects using a wide-angle lens to show perspective. The object closest to the lens will be distorted in size, giving the illusion that the subjects are all different sizes.

162

When you photograph a distant scene, if all the subjects are on the same plane of focus, there is the tendency for it to feel flat with no feeling of depth.

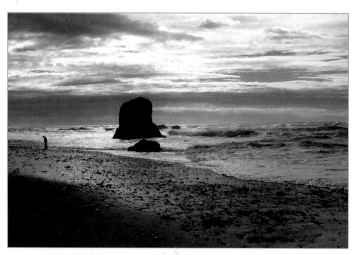

163

If you add something in the close foreground to frame the subject, it now takes on a three-dimensional feel.

164

Camera manufacturers and third-party vendors have a myriad of accessories you can add to enhance your digital camera images.

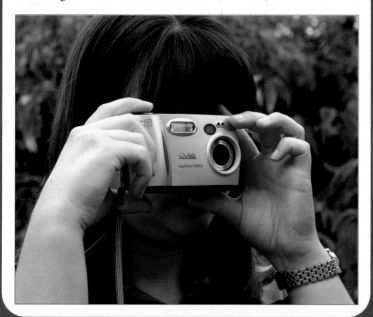

165

There are various filters available for digital cameras. In fact, if you already own filters that you used on your film camera, they will probably work too.

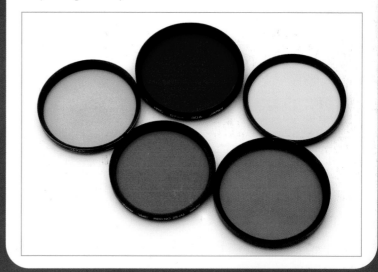

166

Since most digital cameras have a smaller lens, the filters you already own may be too large. Not to worry as you can purchase step up or step down rings to adapt your filters to fit on your new digital camera. If your digital camera has a lens that recesses into the camera body when it powers down, make sure that the filter fits properly or it may jam the mechanism.

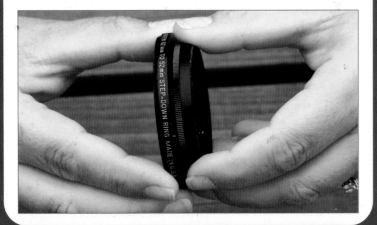

167

Here is an image created at our local boat harbor. Note that the sky looks drab with low contrast and little color saturation. Let's look into our filter collection to see if we can improve this photo.

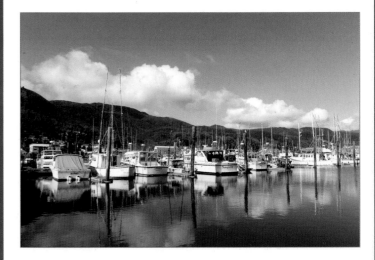

168

One of the more popular filters is the polarizer filter. This blocks out certain portions of the light wavelength so as to enhance the contrast and saturation of the sky and water reflections.

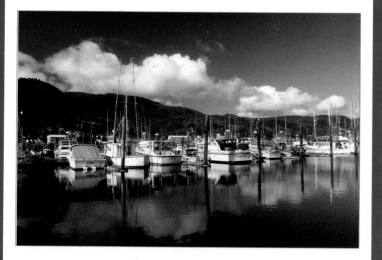

169

Some of the special effects filters used with film cameras can also be used with digital. The star filter provides added impact to photos taken with sunbursts.

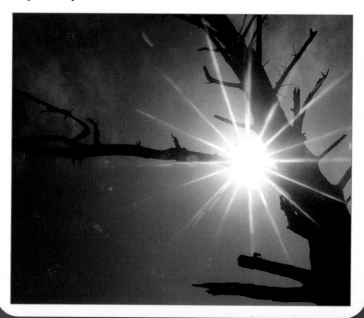

170

When you have a subject very close to the lens and another far off in the distance, you may find that even with a small aperture, the depth of field cannot keep them both in focus.

171

The solution is to use a split focus filter. This filter resembles a bifocal because one half contains no glass and the other half contains a diopter. This allows you to position the filter so that the diopter views the closer subject and the area without glass is positioned to photograph the distant subject. The result is that both subjects are in sharp focus.

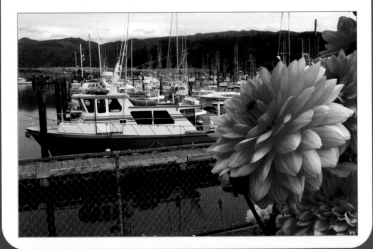

172

If your camera cannot focus close enough to satisfy your photo needs, there are several manufacturers that make close-up lenses that can be attached to the front of your digital camera lens.

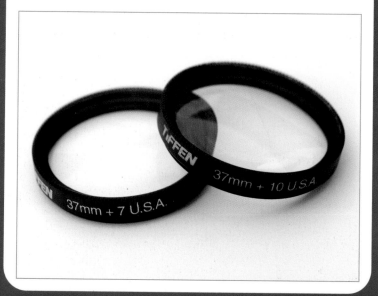

173

Best of all, you can immediately see your results on the LCD viewer and check your framing and focus.

174

When you find your photos lacking in color, there are even more filters available to help you perform magic tricks.

175

Graduated filters blend from one color to another, providing hues you never thought possible.

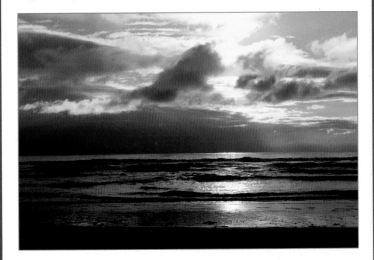

176

An unusual digital camera accessory lens is the fisheye. It simply attaches to the front of your camera using a special mount.

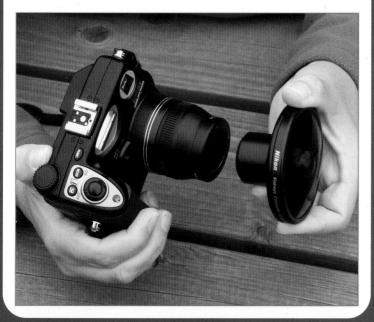

177

This really wide lens will almost photograph everything in front of the camera. Although the image appears distorted, it can surely provide unique images for your portfolio.

178

Your digital camera is a fragile instrument. It requires care when used, stored, or transported.

179

One of the most critical parts of your digital camera is the lens. It is the eye of the camera and needs to be protected. Be sure to attach the lens cap when your camera is not in use. If your digital camera has a protective door that slides over the lens, be sure to use it when you are done taking pictures. Make sure to use the camera strap when using or carrying your camera to ensure its safety.

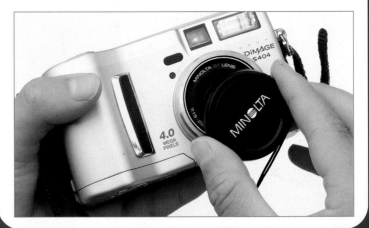

180

Dust and small particles can be removed from the surface of the camera and lens with a lens brush. When you squeeze the bulb at the end of the brush, it expels air to aid in your removal of unwanted dust particles.

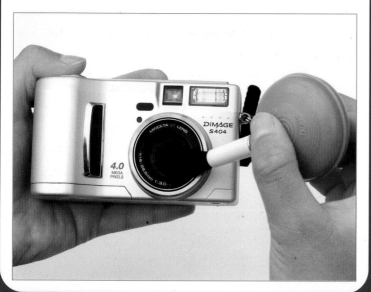

181

If your lens needs more attention than the brush can provide, you can use a specially made lens-cleaning tissue and cleaning fluid. Be sure to apply the solution to the tissue, not directly onto the lens.

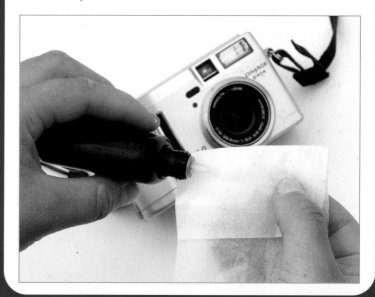

182

Apply the damp tissue and gently clean the lens using a circular motion.

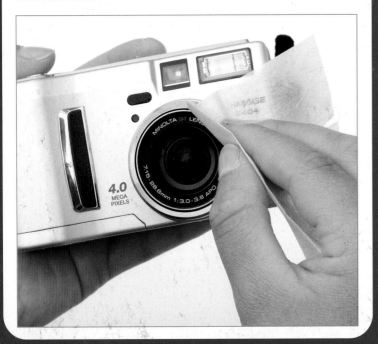

183

To remove fingerprints from your LCD viewer, you can use a soft camera-cleaning cloth to gently polish the surface.

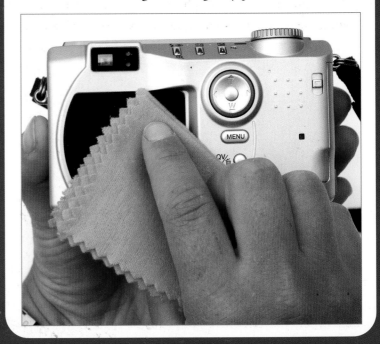

Now that you have come to the final chapter, we hope that you have successfully taken many digital photos. Of course, there will be some good ones

We hope that you have successfully taken many digital photos.

and some others that could have been better, but that's all part of the learning process.

Digital makes it easy to learn. You can try a technique, check your results, make adjustments, and then try it again. Best of all, you can share your images immediately with family and friends.

The best way to learn to take better pictures is to practice. Take plenty of images because you no longer have to worry about film and processing costs.

Once you and your digital camera have mastered this book, consider moving on to our *Advanced Digital Camera Techniques* book (also from Amherst Media) for more advanced skills and creative techniques using a digital camera.

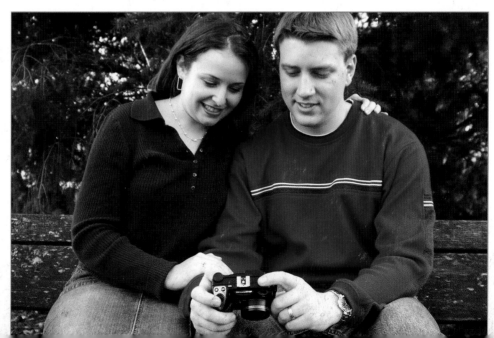

Other Books from
Amherst Media®

Photo Salvage with Adobe® Photoshop®

Jack and Sue Drafahl

This indispensible book will teach you how to digitally restore faded images, correct exposure and color balance problems and processing errors, eliminate scratches and much, much more. $29.95 list, 8½x11, 128p, 200 full-color photos, order no. 1751.

Plug-ins for Adobe® Photoshop®

A GUIDE FOR PHOTOGRAPHERS

Jack and Sue Drafahl

Supercharge your creativity and mastery over your photography with Photoshop and the tools outlined in this book. $29.95 list, 8½x11, 128p, 175 color photos, index, order no. 1781.

Advanced Digital Camera Techniques

Jack and Sue Drafahl

Learn the techniques you need to maximize your digital camera images and creativity. Learn techniques for zoom exposures, close-ups, panoramics, and much more. The perfect book for those looking to take their images to the next level! $29.95 list, 8½x11, 128p, 150 full-color photos, order no. 1760.

Beginner's Guide to Adobe® Photoshop®

Michelle Perkins

Learn to make your images look their best, create original artwork or add unique effects to any image. All topics are presented in short, easy-to-digest sections that will boost confidence and ensure outstanding images. $29.95 list, 8½x11, 128p, 150 full-color photos, order no. 1732.